Penguin Books

Penguin New Art 2 Advisory Editor: Richard Morphet

20 -84

Christopher Finch, born in the Channel Islands in 1939, studied at the Chelsea Art School. He was on the staff of the Walker Art Center in Minneapolis where he edited *Design Quarterly.* He is now working freelance in New York. Some of his major articles have appeared in *Art and Literature, Art International, Art and Artists, Vogue* and *New Worlds,* he has written two books, *Pop Art* (Studio Vista, 1968) and *Image as Language* (Pelican, 1969), and is currently writing another Pelican book, to be called *New Arcadia,* in collaboration with Eduardo Paolozzi. He has acted as interviewer and consultant on two films for the Arts Council of Great Britain on R. B. Kitaj and Richard Hamilton.

Patrick Caulfield

by Christopher Finch

Penguin Books Ltd, Harmondsworth, Middlesex, England
Penguin Books Inc., 7110 Ambassador Road, Baltimore,
Maryland 21207, U.S.A.
Penguin Books Australia Ltd, Ringwood, Victoria, Australia

First published 1971
Copyright © Christopher Finch, 1971
Designed by Gerald Cinamon
Manufactured in the United States of America

Library of Congress Catalog card number 76–109891

Contents

Patrick Caulfield:

1936	Born in London
1956–9	Chelsea School of Art, London
1959–63	Royal College of Art, London
1964 to the present	Teaching at the Chelsea School of Art; living and working in London

One-man exhibitions

1965	Robert Fraser Gallery, London
1966	Robert Elkon Gallery, New York
1967	Robert Fraser Gallery, London
	Studio Marconi, Milan
1968	Robert Elkon Gallery, New York
1969	Waddington Galleries, London

Group exhibitions

1961, 1962, 1963	Young Contemporaries, London
1964	The New Generation, Whitechapel Gallery, London
1965	4ème Biennale des Jeunes, Paris, Graphics Exhibition
	'Saison de la Nouvelle Peinture Anglaise': Patrick Caulfield / Derek Boshier, Galerie Aujourd'hui, Brussels
1966	Robert Fraser Gallery at Studio Marconi, Milan
1967	'Jeunes Peintres Anglais', Palais des Beaux Arts, Brussels
	5ème Biennale des Jeunes, Paris, One-Man Print Exhibition
	'Recent British Painting', Tate Gallery, London
1969	'Marks on Canvas', Museum am Ostwall, Dortmund

It is quite common today to talk of an international style as though work produced in New York, London, Paris, Milan, Tokyo and Los Angeles is somehow basically alike. Certainly there are surface similarities between works of art produced throughout the world — after all, new art becomes known overnight through mass media and the art magazines — yet it is impossible, when discussing a painter like Patrick Caulfield, to ignore the fact that he is specifically European, that he is English. Especially if one considers Caulfield's art in relation to American art, which has been internationally dominant for almost two decades, the Englishness of his work becomes almost its most essential characteristic. American art functions within a value system quite different from those that are still prevalent in Europe. Almost no European artists have managed to adapt to the American value system with any degree of success and those few that have — Richard Smith is perhaps the most notable example — have done so as the result of a long residence in the United States. From the American point of view, European art seems, for the most part, to be in a dismal state of disarray; painters and sculptors trying to squeeze the last sap from a dying aesthetic. It should be no surprise to hear Frank Stella or Don Judd dismiss a painter like Vasarely as being fussy and over-complex.

The English artist is, of course, in a privileged position vis à vis his American counterpart; he shares a language and sizable chunks of cultural heritage. He watches American movies and TV shows without subtitles. This gives him a distinct advantage when it comes to under-standing American art; at the same time he remains essentially European (so long, at least, as he stays in Europe). English artists then are in a unique position to use their special knowledge — be it intuitive or conscious — of American art to help resolve the problems inherent in European art in the second half of the twentieth century. Patrick Caulfield is, I believe, one of the artists most capable of contributing to such a resolution and so, before turning to any detailed discussion of his work, I think it might be advantageous to take a closer look at this situation.

It would be practically impossible to set down on paper 'the American system of values as it applies to art'; rather, we might discuss a few characteristics that seem strongly in evidence in recent American art. Firstly, perhaps, its appeal is essentially to pragmatic values. (Don Judd has said that what exists exists.) Judd's objects, like those of Robert Morris, Carl Andre, Richard Serra and many others, merely exist, rely for their impact upon their insistent presence. Morris has emphasized the importance of

objects existing in actual space where the force of gravity becomes an active ingredient of our knowledge about them. Common-sense reality, objects that can be touched and experienced in the round — these are values that are respected. They need no justification. Specificity takes on a great importance — the fact that a piece consists of eight identical parts and is constructed from $\frac{1}{8}''$ sheet copper (Judd has, in fact, written about 'specific objects').

American artists are very conscious of the differences that exist between their work and that of their European contemporaries. Judd, in an interview with Bruce Glaser, discussed the qualities of European art in the following terms: 'They're innumerable and complex, but the main way of saying it is that they're linked up with a philosophy — rationalism, rationalistic philosophy.' After a passing mention of Descartes, Glaser asked if Judd meant to say that his work is apart from rationalism. Judd agreed that he did mean just that: 'All that [European] art is based on systems built beforehand, *à priori* systems; they express a certain type of thinking and logic which is pretty much discredited now as a way of finding out what the world is like'. In short, then, what is being challenged by American art is not just the value system of the European art world but an important part of the European intellectual tradition.

The European artist must today admit to the power and, therefore, the new conditions created by American art. In England this is not such a great problem (or, rather, it *was* not such a great problem when the London scene was beginning to establish itself in the late fifties and early sixties). England had been patronizingly treated as a provincial cousin during the great period of European modernism and so had little difficulty in transferring its allegiance to the new American painting when the abstract expressionists, and artists such as Johns, Kelly, Louis and Noland, first began to get exposure in Europe. The English artist — unconditioned by the sequence of ideologies that still exercised their residual legacies on the mainland of Europe — was easily able to accept and adapt to the jargon of allover painting, color fields, stain painting and so forth. The stylistic features of successive American idioms have been adopted without effort; the problem has arisen from the fact that it is very difficult for an English artist to duplicate the mental processes that lie behind these stylistic innovations outside America. He can come close but never go the whole way (Richard Smith's early paintings indicate that he had come very close but it is not till the work done during his first period of residence in the United States that his canvases take on real authority). To produce able but hollow paintings based on current American idioms was naturally unacceptable to the more

perceptive English painters. It is where some English painters attempted to resolve the problem in their own terms, but using the given elements borrowed from American art, that Judd's comments become critical. These solutions — or non-solutions — expressed that 'certain type of thinking and logic' which betrayed them. To anyone who understood how these idiomatic elements had been arrived at originally, this use — or misuse — could only seem absurd, or sad, or both. The most obvious feature of American-derived English painting is that it looks too composed and often too complex. Frank Stella, taking part in the same interview with Judd and Glaser, talked about what he called 'relational painting' (he was referring specifically to geometric painters such as Vasarely, but his comments can probably be extended to cover European painting as a whole): 'The basis of their whole idea is balance. You do something in one corner and you balance it with something in the other corner. Now the "new painting" is being characterized as symmetrical. Ken Noland has put things in the center and I'll use a symmetrical pattern, but we use symmetry in a different way. It's non-relational. In the newer American painting we strive to get the thing in the middle, and symmetrical, but just to get a kind of force, just to get the thing on the canvas. The balance factor isn't important. We're not trying to jockey everything around.' Stella is describing the directness and force that is conspicuously absent from almost all English art done in a neo-American idiom.

When the new English painting is discussed, some feel that it is generally the figurative painters such as Richard Hamilton, Allen Jones, David Hockney, Peter Phillips and Caulfield who make the strongest showing. Those who have dealt very specifically with Pop imagery seem to be in a privileged position. Unlike their counterparts on the mainland of Europe, they have been brought up in a cultural environment where American popular imagery is an active ingredient. At the same time, however, they are removed from the source of this imagery and thus have a very different perspective of it to that offered by American Pop artists. Their relative detachment has led to a kind of analytical Pop Art which is quite different in character from the Pop Art produced in New York or Los Angeles. American artists such as Warhol, Lichtenstein and Olden-burg have presented, within a figurative idiom, images as direct and uncompromisingly specific as those evolved by Stella, Judd or Morris. English Pop painters have not — but they do offer other and compensating qualities. The imagery is strong enough to hold up by itself and to look at it in this perspective is at least interesting (since it is not an artificial perspective but one which has grown

naturally out of the artists' background). Admittedly there is a danger that this analytical type of painting may become either academic or an exercise in social commentary, but there is evidence — in paintings by Peter Phillips, for example — that this approach can resolve itself into plastic statements of real force.

Patrick Caulfield has sometimes been associated with these Pop-oriented painters; certainly he does share common characteristics with some of them. But his art differs from theirs at a rather fundamental level. Like them he has made use of pre-existing imagery — often of a very banal kind. The sources and range of his imagery, however, differ very considerably from those of his contemporaries. You do not find in his work details from customized cars, pin-ups, New York skylines, *Scientific American* diagrams, etc.; his banalities are taken from sources nearer to home. The imagery of English Pop Art is not in fact for the Englishman especially banal — rather it is exotic. The American landscape — familiar from childhood by way of movies and magazines — has the same mysterious appeal for the English today that the Islamic world seems to have had for their ancestors in the eighteenth and nineteenth centuries: Fred Astaire and Ginger Rogers replaced Vathek and Omar Khayyam some time between the wars. Not that the English Pop artist's vision of America is entirely romantic considering its analytical aspect; but even at its most analytical it contains the residue of exoticism (rather like Doughty's descriptions of Arabia). When Caulfield includes the exotic in his work, it is always a traditional and obvious kind: palm trees and oriental pottery often appear in his painting. His is a deliberately banal and apparently ironic statement of exoticism. What Caulfield actually does is deal with visual clichés and to be fully effective they must be so familiar as to be almost totally dumb (so that when he portrays oriental objects he is not so much indulging in exoticism as presenting a cliché about exoticism). The visual cliché is a salient feature of Caulfield's work and, as other critics have pointed out, his paintings exploit the shock of recognition, the elevation of the familiar. His use of the banal, however, cannot be simply summed up in this way. To Caulfield clichés are also interesting: there must be some good reason why they became clichés. Clichés are trite because they are statements of obvious truths — but does that make them any less true? Certainly some are untruths or half-truths but, in order to become clichés, they must at least have inspired belief at some time.

One could even say that, in some of his best paintings, Caulfield restores dignity to visual clichés (and to the truths and beliefs behind them). But there is a good deal

of complexity behind the apparent simplicity of his plastic statements. Few European artists in the last few years have managed to put on to canvas such simple statements with so much authority. The directness and specificity of his best work is different from that of his American contemporaries, but it can be compared to theirs without embarrassment. Caulfield seems in fact to be admitting and turning to his advantage what is implied in the criticism of European art by Americans like Stella and Judd who maintain, in effect, that European artists work in a cliché situation. This may not have been a programmatic decision on his part but it is, none the less, implicit in his work.

The main advantage Caulfield seems to have gained from contact with American painting is that it has given him a new perspective on European art. Unlike his contemporaries in New York, he has not used this perspective as a reason to abandon the old tradition. Nor, on the other hand, has he attempted to renovate that tradition. Rather Caulfield takes the banal remnants of a once lively cultural system and attempts to distil from them the essence of the experience of reality they represent today. His position is contrary to that held by the abstractionists of the heroic period of European modernism, and by their successors today. They stripped European art of its existential trappings and tried to discover the logic that lay beneath. Caulfield ignores the no longer relevant logic and tries to come to terms with the surface manifestations of European culture. If he sometimes uses traditional compositional devices in his paintings this is only because they have become part of the cliché with which he is dealing.

Patrick Caulfield was born in London in 1936 and brought up partly there, partly in Lancashire. After two years of military service with the Royal Air Force, he became a student at the Chelsea School of Art in 1956. At this time he worked in a *faux naïf* style. One painting of that period showed a figure standing beside an ancient cannon and a neat pile of cannon balls. Although very much a student work, this painting displayed considerable self-confidence. The forms were simplified and distributed with a deliberate gaucheness that was very far removed from the academic considerations that were supposed to be one's main concern at art school. Caulfield's entire attitude seemed different from that which was common amongst the students. There was, at the time, a general dissatisfaction with English art education and English art; Caulfield felt confident that these issues could be resolved although he was not over optimistic as to how his own efforts would be received. In fact he expected that he would have to earn his living as a commercial artist but this did not seem to

worry him unduly. What was perhaps most noticeable was his ironic attitude towards the role of the artist — an irony which contrasted with the seriousness with which he approached his work.

The *faux naif* paintings were soon succeeded by larger and more sophisticated compositions — schematic representations of high-rise apartment blocks painted on hardboard in flat commercial colors. These were followed by Caulfield's one direct involvement with American painting.

Like other young English artists he was impressed with the work of the abstract expressionists and produced a number of very elegant and accomplished — though tentative — paintings in an idiom related to the work of Philip Guston. It was perhaps as a result of these paintings that Caulfield gained a new perspective on European art. Certainly this was when a number of options were explored.

In 1961 — by now a student at the Royal College of Art — Caulfield exhibited a group of paintings at the 'Young

1. *Leaving Arabia,* 1961

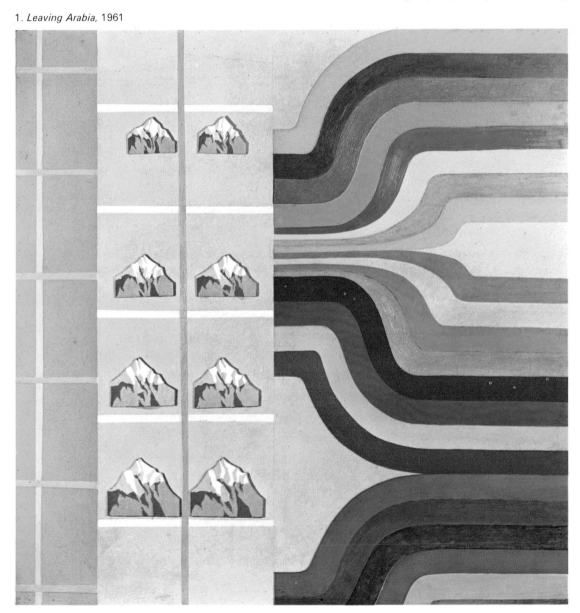

Contemporaries' exhibition which contained the first hints of his mature style [1, 2]. In these, simplified images were juxtaposed with bold, solid grids of color. At first sight these paintings seemed to consist of a straightforward combination of figuration and abstraction (itself a novel enough idea in English painting at that time); moreover the abstract elements were of a very sophisticated order since they were not compositional devices in any traditional sense — they were simply symmetrical patterns[1].

What distinguished them primarily was their concreteness. At this time most of his contemporaries were — even within a Pop-oriented figurative context — still concerned to a degree with gestural painting. Allen Jones's figuration, for example, seemed to emerge at that time from gestural color fields and he has said of canvases of this period that they were about deep space — about the picture as a field to be activated. Paint was to be used primarily as a spatial marker and only secondarily as a vehicle for imagery. Thus

2. *Upright Pines,* 1961

16 Jones, along with his interest in figuration, was still, it would seem, absorbing the lessons of Abstract Expressionism. David Hockney's paintings of the early sixties also had a sketchy gestural quality — used with great panache — which recalled the calligraphy of the fifties. I recall that the first Hockney paintings I ever saw, around 1959, were in an idiom strongly reminiscent of Alan Davie. Even Peter Phillips — who was already including hard-edge geometrical forms in his paintings — would occasionally indulge himself in gestural smears of pigment. Caulfield, on the other hand, was presenting hard, flat, glossy images that lay blandly on the picture surface like butterflies pinned to a board.

This emphasis on directness of presentation and concreteness led, soon after these first paintings were exhibited, to an experiment in which the picture plane was replaced by an actual wooden grid — a simple kind of lattice structure — to which cut-out and painted images were attached. Two or three 'trellis paintings' of this kind

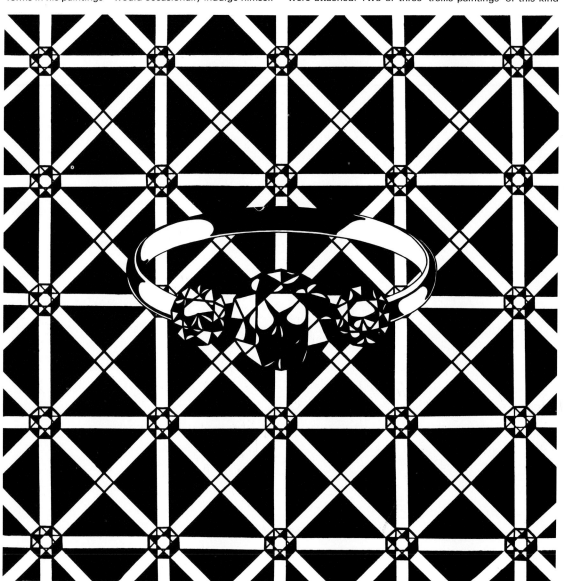

3. *Engagement Ring,* 1963

were executed before the experiment was abandoned. The trellis motif however — a logical development of the earlier grid motif — was later used with great effect in a number of more conventional paintings. Best known amongst these are probably the *Engagement Ring* [3] and *Black and White Flower Piece* [4], both painted in 1963. These paintings are executed in sharp black and white monochrome and present the figurative image — far more boldly conceived than in the 1961 paintings — placed centrally against the simple symmetrical grid. In *Engagement Ring* jewel-like images are placed at the intersections of the white lattice and the symmetrical facets of the diamonds set into the ring itself echo the total symmetry of the composition. The overall character of the painting is quite different from Roy Lichtenstein's *The Engagement Ring* painted in 1961 (Caulfield had not seen this painting at that time). Both paintings are very direct, but there the similarity ends. Lichtenstein's image reads as a straight

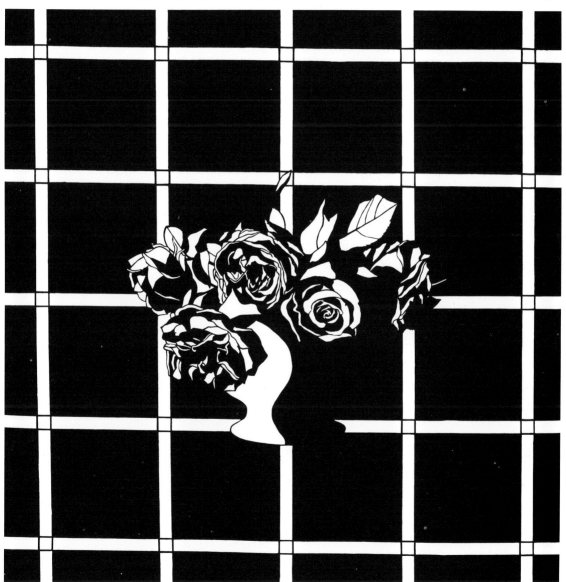

4. *Black and White Flower Piece,* 1963

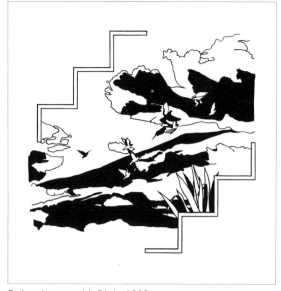

5. *Landscape with Birds,* 1963

In other paintings of this period Caulfield deployed his hard-edged monochrome to slightly different ends, abandoning the crutch of the background symmetry. For example in *Landscape with Birds* [5] the figurative image occupies virtually the entire picture plane. The subject matter has once more the quality of visual cliché which was already a recognizable feature of Caulfield's work — seeming, in this instance, to have strayed from some canvas by Vernon Ward. A flock of birds is seen flying against an expanse of clouds. The composition follows a diagonal from bottom left to top right and is hemmed in by a zig-zag device the function of which appears to be purely decorative. A token sample of vegetation seems to sprout from the bottom right zig-zag which lends it, to some extent, the feeling of architecture. The combination of simplified black and white image and decorative overall concept make this painting in some ways comparable with a drawing by Aubrey Beardsley. On closer inspection, however, one realizes that it has none of the literary quality associated with Art Nouveau. Rather it is a carefully considered

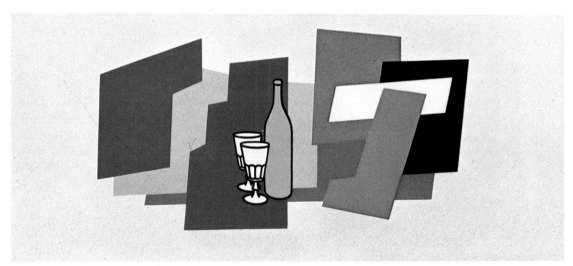

6. *Still Life with Green Bottle,* 1964

reproduction of a newspaper advertisement. Caulfield's image clearly takes its inspiration from the same source but has been conceptualized to a far greater degree. Lichtenstein's painting is quite frankly derived from an image that had already been reduced to two dimensions. Caulfield's makes great play of the contrast between the slick illusion of three dimensions in his portrayal of the ring and the two-dimensional pattern of the background grid.

exercise in tensions between three-dimensional image and two-dimensional surface. Once again this distinguishes it sharply from the intentions of an artist like Lichtenstein who may achieve a similar impact but usually by reproducing an image that has already been reduced to two dimensions rather than by putting a three-dimensional subject through the conceptual processes that we see at work in Caulfield. This may seem a small distinction but

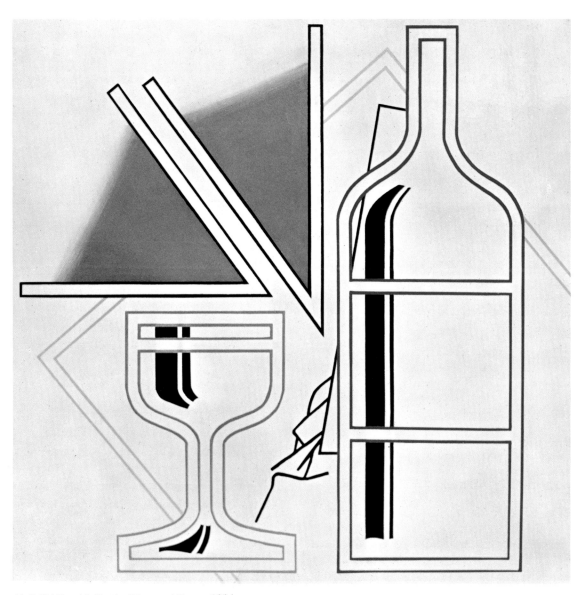

7. *Still Life with Bottle, Glass and Drape,* 1964

considered in the context of the art of the sixties it is an important one.

Perhaps the most interesting, if not always the most successful, of the paintings done at this early stage of Caulfield's career are what have been described as the 'cubist' still-lives [6, 7]. These have been widely misinterpreted as a rehash of cubist painting and it is not difficult to see how this misconception has arisen. They

usually consist of elements that appear to have been borrowed from a canvas by Juan Gris — formalized bottles, wine-glasses, drapes and so forth. Elements that were, in cubist paintings, utilized structurally are here abstracted and put to an apparently decorative use. If these paintings were, indeed, a rehash of cubist ideas they would be especially uninteresting but it should be pretty obvious, from a consideration of the artist's work as a whole, that

he would not attempt anything so foolish. These paintings are not so much reconstructions of cubist paintings as paintings *about* cubist paintings. They use ironical visual quotations from cubist masterpieces to say something about the artist's relationship to the tradition of European modernism. These quotes are ordered with the same plastic sophistication that we find in paintings such as *Engagement Ring* and *Landscape with Birds* – but this time the clichés used are those of fine art rather than those of popular culture. They are, however, used with the same detachment – ironical but essentially sympathetic. In these paintings Caulfield seems almost to be trying to establish his identity as a European artist. He realizes that it may be impossible, in the light of American painting, simply to take up where Gris or Picasso or Matisse left off; but he can perhaps retain some links with the European past.[2]

What is remarkable is the degree to which in these years – from 1961 to 1963 – Caulfield did succeed in establishing an identity. The fact that he was employing mostly banal imagery did not prevent him from finding a highly personal idiom. Although he developed this independently, he was not unique in achieving it at this time; in New York, Lichtenstein, Warhol and Oldenburg were following a parallel route.

There were other highly talented artists making their presence felt in London at the same time, but it is remarkable how sure of his personal identity Caulfield seemed, developing within a matter of a year or two a mature style. Others – and this, of course, does not in any way reflect upon their ultimate achievement – seemed to move by a process of trial and error: they appeared to take longer to sort the central concerns of their art from the incidentals. This should not be too surprising since the origins of the new painting in England were rather divergent. There was the admiration for some of the achievements of early European modernism – Léger, Delaunay and the Surrealists were favorites of the period. At the same time there was the feeling that New York painting offered an alternative to the École de Paris. What also emerged as an important factor was the involvement with popular culture and the side products of technology. In the early sixties most people were attempting to resolve the differences that seemed to exist between different possibilities; they were content to explore their options. The English art scene developed by an elaborate process of synthesis (a factor which made it a fascinating field of study for the critic but which may, in the long run, prove to be its undoing. One or two artists have, undoubtedly, managed to resolve the difficulties involved in a synthesis of this sort but for others the contradictory motions of the

influences at work may have been too powerful to allow any personal resolution). Caulfield seems to have had, from a very early stage, the confidence to sidestep many of these problems; he chose his options rather than explored them. Although he learned from American art — and must always have remained aware of it — he was not, from 1961 onward, ever tempted to experiment with its idioms.

It is perhaps worth remarking that by being consciously a European — by ignoring the exoticism of transatlantic imagery — he probably came nearer than any of the other London based figurative artists to the spirit of his American contemporaries. He was not forced to adopt the analytical perspective — the interpretation of media images — that is so typical of English Pop Art and so conspicuously absent in New York Pop. At the same time it must be admitted that he was not able to take as much for granted as did the American artists, simply because he was in such an isolated position. While he may have been sure of his own identity and intentions, he was obliged to almost spell them out in his paintings; hence the paintings *about* Cubism.

Till now, Caulfield's public exposure had been very limited but already one or two collectors — notably Alan Power — had begun to take a serious interest in his work. Until 1963 he was still a student at the Royal College of Art, yet he had already established a considerable reputation amongst the artists who were his contemporaries and immediate elders. When he left the Royal College to take a part time teaching post at Chelsea Art School, the basics of his idiom were already established.

In 1964, under the auspices of the Peter Stuyvesant Foundation, Bryan Robertson of the Whitechapel Gallery organized the first in a series of exhibitions to be titled 'The New Generation'. It was as a consequence of his participation in this exhibition that a wider public became aware of Caulfield's work.

At 'The New Generation' each of the twelve artists exhibited four paintings. Caulfield showed two paintings from 1963 — another and more formalized version of *Landscape with Birds* [8] and *Portrait of Juan Gris* [9] — plus two from 1964 — *Still Life with Necklace* [10] and *Santa Margherita Ligure* [11]. Of the two earlier paintings, the portrait is perhaps the more interesting since it illustrates in an emphatic form what was said previously about the 'cubist' still-lives. Juan Gris is portrayed in flat, bland colors against a yellow ground. The figure is hemmed in by decorative devices which seem to have been derived from compositional elements in his own paintings. This is quite clearly *not* a cubist painting but, on the other

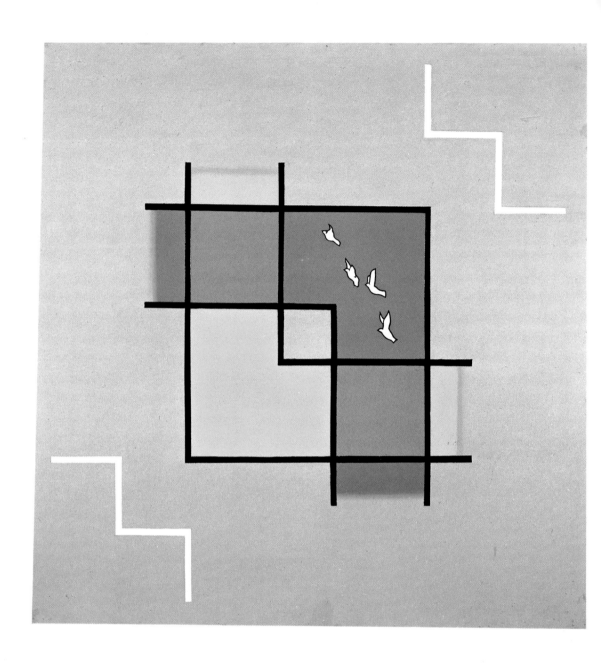

8. *Landscape with Birds,* 1963

hand, it is obviously a painting *about* Cubism and the era of Cubism. The conventional bottles and tumblers of the still-lives are here replaced by the portrait of an actual cubist painter – Caulfield turns from icons to icon-maker. This painting is undoubtedly intended as a tribute to its subject but, more importantly, it is a clear example of Caulfield's willingness to demonstrate his European heritage.[3]

In the two more recent paintings Caulfield abandons the square format, which he had favored up till that time, for elongated, horizontal rectangles. This was an important break since it corresponds with a shift from his reliance upon symmetry and centrality of image placement. He did not abandon these devices completely but they become from 1964 onward less of a fixed convention in his work.

9. *Portrait of Juan Gris,* 1963

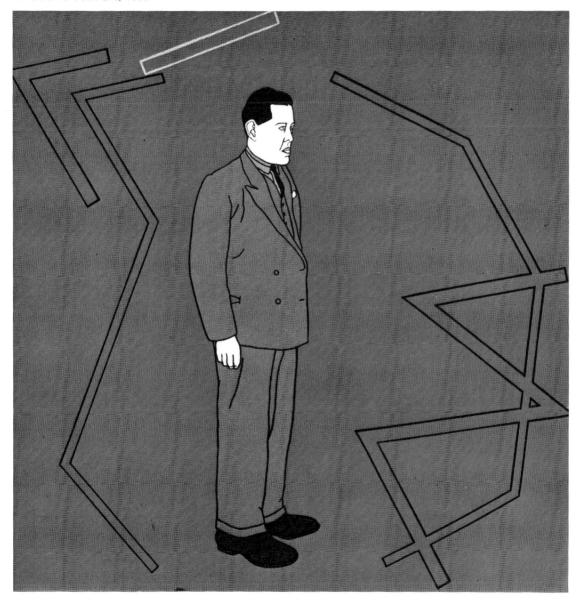

Santa Margherita Ligure [11] represents something of a departure in that it presents a single coherent and fairly complex image which fills virtually the entire picture plane. It represents a conventional Mediterranean view which was borrowed from a postcard (in composition, though not stylistically, it also recalls paintings by Matisse and Bonnard). A balcony with wrought iron balustrades overlooks the sea. A vase of roses stands on a circular table and other flowers are placed on a stone pillar. A sail boat is seen against the blue of the sea. The entire image is hemmed in by a geometrical device but this has become almost insignificant.

Still Life with Necklace [10], by contrast, still featured the cubist-derived geometry as a combined decorative and

Caulfield talked, in 1963, of his ambition to arrive at a visual language as fixed and formal as that of, for example, Egyptian art. He did not see this as an attempt to suppress subjectivity. He thought of it more as a necessary discipline that would allow him to make the kind of statements he felt he must make. During that period he was, it would seem, attempting to distil this formal language from a variety of sources. This was not the subjective synthesis that we find in the work of most of his English contemporaries but, as already suggested, a detached and highly selective process. It was as though he had already selected the elements of vocabulary that would form this language (this is exactly what I mean when I say that he was more certain of his identity than were most of the other painters

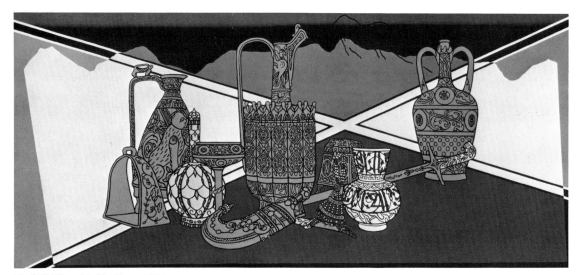

10. *Still Life with Necklace,* 1964

compositional device. Again, however, we are presented with a more complex image that fills virtually the entire picture plane. Like *Santa Margherita Ligure* it exploits a cliché of exoticism — in this instance the fascination with oriental art: apart from the necklace of the title, middle-eastern silverware, pottery and daggers are portrayed. It seems, in retrospect, a less successful painting than *Santa Margherita Ligure* just because it does depend to such a degree upon geometrical devices to hold it together. In the light of his later achievements these seem unnecessary. In the context of his progress to that date, however, they do make complete sense.

at this time). All that remained was for him to make the syntax work.

In *Still Life with Necklace* the syntax seems a little contrived but this is one of the last paintings of which this could be said. In his work from this time onwards, Caulfield's use of visual syntax seemed completely self-assured. In the majority of paintings done since 1964 Caulfield has excluded geometrical devices entirely. In others, for example, *Red and White Still Life* [12], he has used borrowed geometries in a bold and imaginative way. Another interesting early example is a painting called *The Artist's Studio* [13], also painted in 1964. In this com-

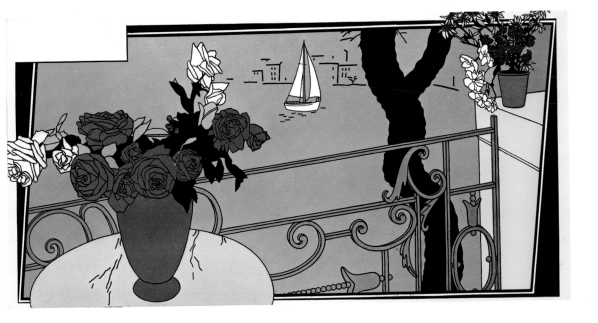

position — which utilizes the long horizontal format of *Still Life with Necklace* — there are two recognizable figurative elements. One of these is a highly decorated middle-eastern pot and the other a sketchy representation of a Mediterranean scene. A good two thirds of the picture plane is, however, occupied by what appears to be a rather inept *moderne* design (it should be noted that *moderne* style appears in Caulfield's work more than a year before it is found in Lichtenstein's).

Caulfield must always have known that his use of cubist devices was essentially a deployment of fine-art clichés. In *The Artist's Studio* he compounds the cliché by quoting an already clichéd derivative of Cubism. The earlier 'cubist' still-lives displayed a definite irony. *The Artist's Studio* is almost openly humorous. Pattern can be used here as pattern because its absurdity is frankly admitted. The geometry is not used to hold the composition together since the geometry *is* the composition. The title of the painting — a cliché in itself — adds to the irony but is supported by the fact that one form in the *moderne* decoration might be taken for a palette and the Mediterranean view appears to be framed. The tongue-in-cheek character of this composition might be taken as a measure of the degree of confidence that he had by now acquired. No one who was not certain of his artistic identity and of his ability to carry out his intentions, would have dared to embark upon a painting such as this.

From another point of view decoration is perhaps the subject of this painting. For some time Caulfield had asserted that decorative painting was nothing to be ashamed of. He would point to the example of an artist

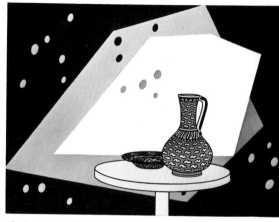

12. *Red and White Still Life,* 1964

like Uccello, indicating that there are many cases of painters making successful use of decorative compositions in a worthwhile and meaningful way. It would be a mistake, however, to see *The Artist's Studio* as an exercise in decoration. It seems rather to be a painting about decoration — just as the earlier still-lives had been paintings about Cubism.

Despite his continuing interest in these matters, I think it is correct to say that the most significant of the paintings shown by Caulfield at the 1964 'New Generation' exhibition was *Santa Margherita Ligure* [11]. The flat planes of color covering the entire picture surface, the images outlined with bold black lines — these were to become the

13. *The Artist's Studio,* 1964

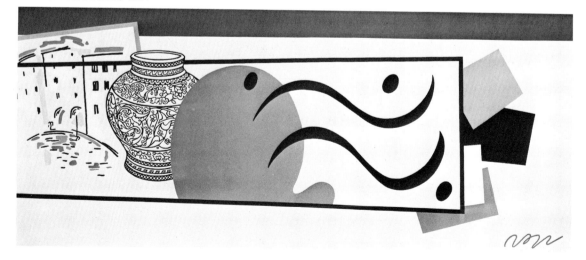

hallmark of Caulfield's most typical work. The painting is a little fussy compared with some later works but the basic idiom is definitely established. In 1963 he had painted a version of Delacroix's *Greece Expiring on the Ruins of Missolonghi* [14] which also displays many of the characteristics of his mature work[4]; but that painting, although something of a tour de force, is perhaps less remarkable than a painting such as *Santa Margherita Ligure* since it was based on a pre-established image and cannot, therefore, have demanded the same kind of compositional decisions.

In the year or so that followed 'The New Generation', Caulfield painted a number of pictures in which the new ideas implicit in *Santa Margherita Ligure* were explored and developed. Most of these found their way into his first one man show which was held at the Robert Fraser Gallery in 1965.

The painting most closely related to *Santa Margherita Ligure* was titled *View of the Bay* [15] and again represents a Mediterranean scene. Small boats bob on an expanse of bright blue sea. In the background can be seen the esplanade of a resort town. Across the foreground is strung a line of bunting. The boats and buildings are represented schematically, outlined in the solid black lines already familiar in Caulfield's work. White and colored reflections are dabbed on to the water as though to parody some painting by Dufy or one of his imitators. The bunting, also outlined in black, is gray and serves to heighten the blue of the water. The entire composition and technique seems to echo the innumerable Mediterranean views that have been painted since the days of the Impressionists — but this is an echo which is at once fond and ironic and which has been transformed cleverly into the idiom of the sixties. Despite the graphic similarity to Post-Impressionist and Fauvist painting, the surface of Caulfield's composition is flat and anonymous; this *View of the Bay* seems to be frozen as though by some over-exposed snapshot. The tension between the two-dimensional pattern of the composition and the three-dimensional reading of the image is extreme. The flatness of the paint lends it a tautness very different to anything that might be found in Fauvism where the softness of the color always allows a degree of depth perception no matter how much the composition is conceived in terms of two-dimensional pattern.

A similar use of taut surface control and two-dimensional pattern in the representation of a three-dimensional subject is to be found in another painting from 1964 — *View of the Ruins* [16]. In this composition the picture plane is occupied by a few fallen stones, some crumbling masonry and some vegetation of the sort that grows in dry places.

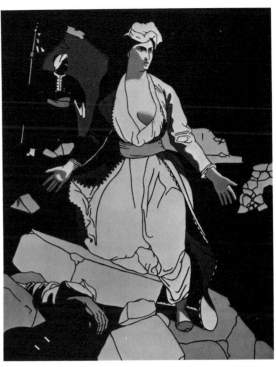

14. *Greece Expiring on the Ruins of Missolonghi,* 1963

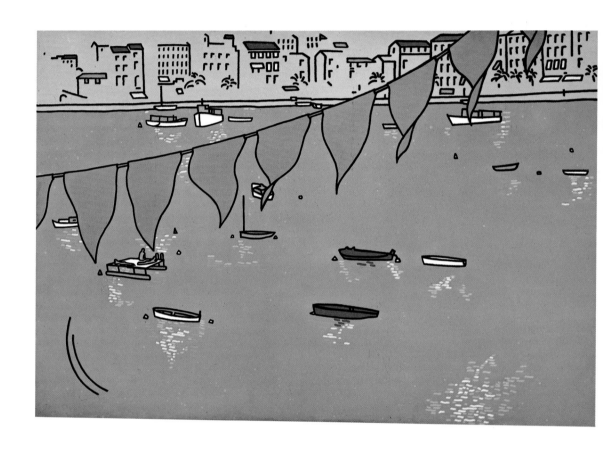

15. *View of the Bay,* 1964

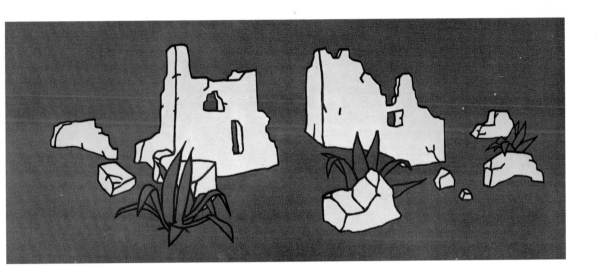

16. *View of the Ruins,* 1964

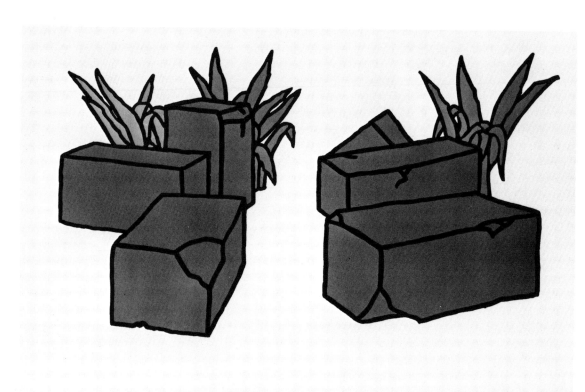

17. *Ruins,* 1964

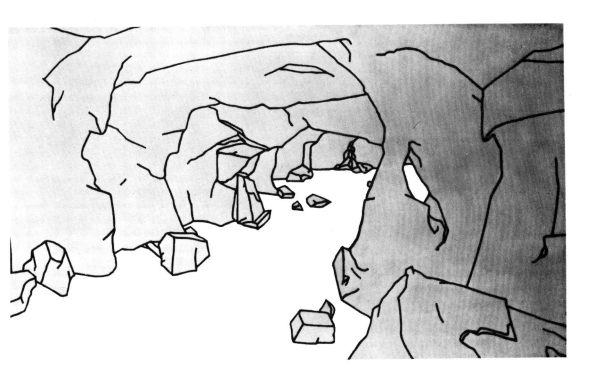

18. *View Inside a Cave,* 1965

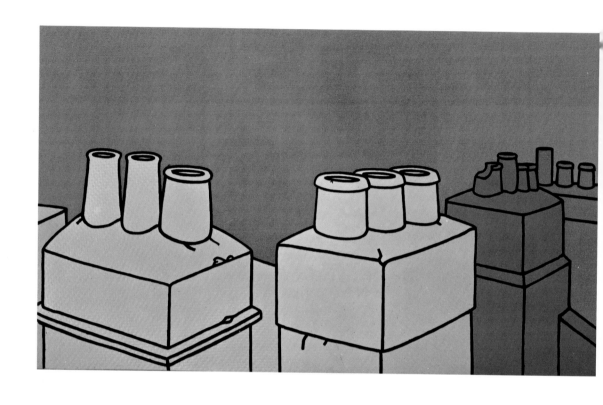

19. *View of the Rooftops,* 1965

Again these images, outlined in black and color combination, are simple in the extreme. There is no attempt to represent shade or to model forms. If we can recognize this subject matter it is because it relates to common images. It is in no way a realistic representation. It is a demonstration of our ability to read pattern as image. A later screenprint, Ruins [17] refines the theme and method of this painting.

These paintings were followed by View Inside a Cave [18] and View of the Rooftops [19] (the constant use of the word 'view' in these titles may itself be seen as something of an irony in the context of these essentially flat paintings). View of the Rooftops shows a landscape of chimney-stacks. The familiar black outlines are filled in with flat colors — turquoise, gray, purple, red — and silhouetted against an expanse of reddish-orange. Here the interest may lie in the fact that the subject matter is in no way picturesque, not even in cliché terms: it belongs to an altogether more anonymous range of banality. View Inside a Cave is an exercise in the distribution of grays though, as usual, the black lines are used to translate what is essentially an abstract composition into a recognizable image.

Two other paintings, Still Life with Candle [20][5] and Corner of the Studio [21], have much of the overall simplicity that is characteristic of the series of 'views' but also return, somewhat enigmatically, to the concerns of the earlier still-lives. In Still Life with Candle a group of objects are portrayed flatly against a gray ground. Across the background are painted two daubs of color — one yellow, one red — which seem to have strayed from some canvas in an altogether more expressionistic idiom. Certainly they have a function in the composition but, more important perhaps, they seem to also have a figurative role as a reminder of historical styles. These daubs seem to belong with the earlier 'cubist' quotations. In Corner of the Studio an old-fashioned stove is the sole subject matter, colored bright red and portrayed against a blue ground. Two geometric shapes appear, however, immediately behind the stove and a delicate fractured pattern in black is scattered about the blue of the picture plane.

If Still Life with Candle and Corner of the Studio do relate somewhat to earlier works, they must, none the less, be included with Caulfield's newer and more confident idiom. The integration of these compositions is smoothly and easily achieved — without the need for contrived formal devices to hold them together. In these paintings of 1964—5 we are confronted with the work of an artist who had found the perfect idiom to express visual statements of a character that had already been implicit in his efforts for some time.

Critical reactions to Caulfield's first show were generally favorable and it was also well received — though this was more predictable — by his fellow artists. Caulfield's work, along with that of a number of his contemporaries, was beginning to be noticed abroad by this time (the younger British artists began to win international recognition at about the time of the 1963 Paris Biennale — an exhibition in which Caulfield was not represented). Caulfield's first major showing overseas came in January of 1965 at the Salon de la Jeune Peinture in Paris. The American poet and critic, John Ashbery, wrote about this exhibition in the

20. Still Life with Candle, 1964

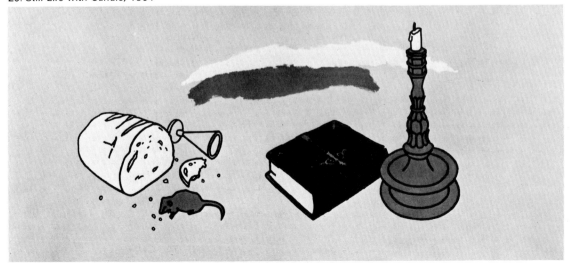

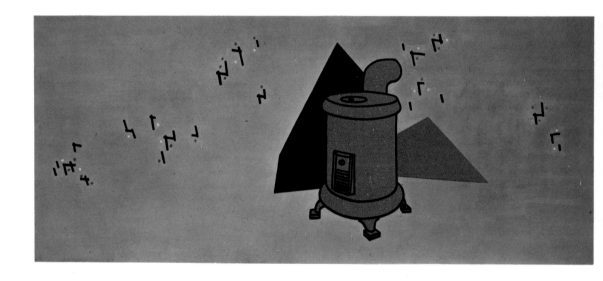

21. *Corner of the Studio,* 1964

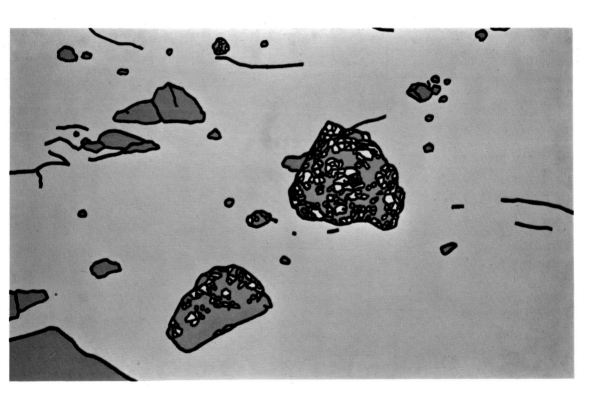

22. *Turquoise in Matrix,* 1966

Paris edition of the *Herald Tribune* and took due note of the English contingent's contribution, reproducing one of Caulfield's paintings – a 1964 canvas titled *Pony*.

He wrote, 'In England, Pop tends to be more picturesque and ingratiating than the New York brand. There are those who complain at this lack of "purity", but actually the Britishers' smoother, suppler work may point the way toward the avant-garde painting of tomorrow. Once we have tired of the Pop artists belaboring the daylights out of our long-suffering "industrial society", we may well look around to see what has happened to painting in the meantime, and some of the young English artists could have the answer.

'This is the impression I got from the large British contingent showing at this year's salon . . . Especially elegant are two works by Patrick Caulfield: a pony with hard outlines like an illustration in a primer, and a sophisticated take-off on Delacroix's *Greece Expiring on the Ruins of Missolonghi*.'

In the next two years, Caulfield's work was seen far more often abroad than in Britain.

In the fall of 1965 Caulfield represented Great Britain at the Paris Biennale and was awarded the Prix des Jeunes Artistes for graphics. Also in 1965, he and Derek Boshier had a two-man show at the Galerie Aujourd'hui in Brussels as a part of the 'Saison de la Nouvelle Peinture Anglaise'. In 1966 he had his first one-man show in the United States at the Robert Elkon Gallery in New York. He took part in a group show at Studio Marconi in Milan and followed this with a one-man exhibition there the following year. In 1967 he also took part, once again, in the Paris Biennale and had another one-man exhibition at the Robert Fraser Gallery – his first major showing in London for over two years. This was followed, in the spring of 1968, by a second New York show at Robert Elkon. Caulfield's confidence at this time was such that he seemed to rely less and less upon an overt exploitation of irony (though it was always present – helping to maintain a detachment between painter and painting, a detachment which is manifest in his technical control). Some paintings seem even to represent a hedonistic involvement with their subject matter.

In 1966 Caulfield painted a small composition titled *Turquoise in Matrix* [22]. This represents exactly what it purports to – crystals of semiprecious stone bedded in lumps of their mother rock; other pebbles are scattered nearby. There seems to be a more direct enjoyment of ʃor in this painting than was to be found in his earlier ʃ. Certainly we cannot but be aware of the expanse

of blue in *View of the Bay*, for example, but there – as in many other compositions – we are conscious of large planes of color overlaid with imagery whereas *Turquoise in Matrix* exploits a complex interplay of color. The background of the painting is gray but this is less noticeable than usual. The blue and purple of the rocks give the composition a jewel-like character which complements its subject. A similar use of color is made in a screenprint of that same year – *Sweet Bowl* [23]. In this composition one is most aware of the brightly colored sweets although they only occupy a small fraction of the picture plane. The blues of the bowl, the table on which it stands, and the background, serve to heighten the intensity of the color in the sweets themselves. This emphasis had seldom appeared in his earlier compositions. These two small works are amongst the most successful that he has ever done.

In paintings such as *Boats at Brindisi* [24], completed in 1965, and *Boat Race* [25], painted the following year, the blue of the sea once again serves as the main planar element in the compositions; but in these works too a richer and more fully satisfying use of color is in evidence. In *Boats at Brindisi* the blue serves as one phase of a color sequence which runs from red to gray to blue to yellow (these colors keyed to the two row boats, the water, and the sand of the beach). No one color seems to be more important in the composition than any other. In *Boat Race* seven brightly hued yachts – reds, blues, yellow, orange, green – scud across the inky blue of the ocean. In the background is a rocky headland and in the immediate foreground the rigging of another yacht which is otherwise unseen. The composition is reminiscent of *View of the Bay* – the headland substituting for the town and the rigging for the bunting – but again the play of color across the entire picture plane seems richer and more sensual in the newer painting.

Perhaps the most clear-cut example of this richer use of color is to be found in a 1967 painting titled *Stained Glass Window* [26]. The ostensible subject of this is a gothic window – viewed in a rather curious perspective since it is drawn as though we are looking up at it and from a slight angle, yet we see it at eye level and head on. The glazed portion of the window is divided into a regular grid of squares which are differentiated by an irregular sequence of colors – red, green, blue, gray, yellow. Optically the impact of this colored grid tends to neutralize the image of the window (an effect which is not uncommon with real stained-glass windows; the windows at Chartres, when hit by the sun, tend to dematerialize the masonry that surrounds them).

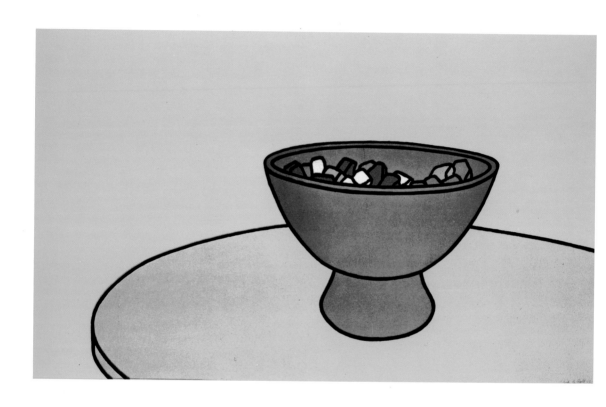

23. *Sweet Bowl,* 1966

24. *Boats at Brindisi,* 1965

Stained Glass Window is complemented by a painting titled *Parish Church* [27] in which we are presented with an exterior view of a gothic building furnished with stained-glass windows not dissimilar to that which is the subject of the other painting. Whereas *Stained Glass Window* completely subordinates the role of figuration to abstract color combinations, *Parish Church* is amongst the most graphically figurative that Caulfield has ever painted. The complex planar structure of the architecture with its tower, its pitched roofs and its buttresses, is clearly articulated so that, for once, the two-dimensional nature of the picture-plane is barely exploited. Color plays a very subordinate role.

Battlements [28] and *The Well* [29] – two more paintings from 1967 – also make use of a monochrome, or near monochrome palette; but they return once again to the tension between three-dimensional representation and two-dimensional surface. Both feature extremely simple images: in one case a circular well rimmed with rough stone-work, in the other a detail of battlements. *Battlements* might almost be a comment on some of Don Judd's reliefs of the same period (the image has the same kind of simplicity and the same serial structure).[6] What is more to the point is that in these two paintings the simplicity of the imagery allows it to be read as surface pattern and only Caulfield's adherence to perspective prevents this from becoming our unique reading.

Bend in the Road [30] – another painting from 1967 – makes highly effective use of both color and the flattening of the image. The color scheme is simple enough – a combination of green and reddish-brown – but the distribution of colors is such that it is essential to the integration of the composition. Caulfield is now able to handle this kind of subject with such ease that he seems increasingly tempted to present a more graphic kind of imagery – a kind of imagery that is not so susceptible to discussion in terms of the straightforward two-dimensional/three-dimensional paradox. *Parish Church* appears to me to fall into this category, as did some of the paintings in his 1968 New York exhibition – notably a rendition of a stereophonic record-player [31] and a painting of water lilies [32]. Water lilies are inevitably associated with Monet but it is something of a surprise to find this 'trade-marked' imagery – tied in the mind to the deep but soft greens and indigos of Monet's palette – edged with black and treated so graphically.

This highlights an apparent ambiguity in Caulfield's work between the anonymity of the picture surface (anonymity is used here only to describe a particular flatness of finish – stylistically the paintings are instantly

recognizable *because* of this 'anonymity') and the sometimes extremely subjective nature of the imagery, subjective in the sense that it seems to help relate Caulfield – at a very personal level – to a cultural pattern.

Throughout his mature career Caulfield has limited himself almost exclusively to flat areas of color, outlined in black, usually against an equally flatly painted ground. The variety of expression he has achieved within this 'formula' is a tribute to his imagination and ample justification of his belief in the possibility of using a formal visual language.

As mentioned before, a number of people have seen a similarity between Caulfield's work and that of Roy Lichtenstein – a similarity which extends to this use of a formal language, and even the kind of language. Certainly a similarity does exist but it should not, in my opinion, be overemphasized. If we look at a Lichtenstein painting – let us take as an example the Tate Gallery's *Whaam!* – we may well discover a use of flat color fields outlined in black but the Lichtenstein painting has characteristics which are not to be found in Caulfield's work. Lichtenstein's outlines, for instance, are distinctly calligraphic; Caulfield's outlines, by contrast, display a more anonymous kind of control – almost as though they have been drawn by a machine. Related to the calligraphy of the explosion and the rocket's path in *Whaam!* is the total effect of the composition, which is essentially dynamic. Caulfield's compositions capitalize upon the fact that they are static (even when he is portraying a subject such as a yacht race there is no illusion of movement). Both Lichtenstein and Caulfield tend to use a very limited color range within any given composition but Lichtenstein's employment of Ben-Day screen dots gives him a greater variety of texture and surface tension which again contributes to the animation of his images. The uniformity of tension across the picture plane in Caulfield's work is, in contrast, an essential device in maintaining the static image quality. Lichtenstein's paintings of that period derive from images already flattened to two dimensions by the commercial artist who had to work within the limits of printing processes for his strip cartoons; the commercial artist, however, was presumably aiming at an illusion of depth and movement and this is retained in the images when they have been adapted, enlarged and translated to canvas. Even Lichtenstein's early more static subjects – such as *Curtains* and *Ball of Twine* – have a degree of calligraphic dynamism. This is seldom the case in Caulfield's work. He too would on occasion work from a pre-existing and flattened source but would always contrive to render the image static by evening the surface tension of the color. In these respects

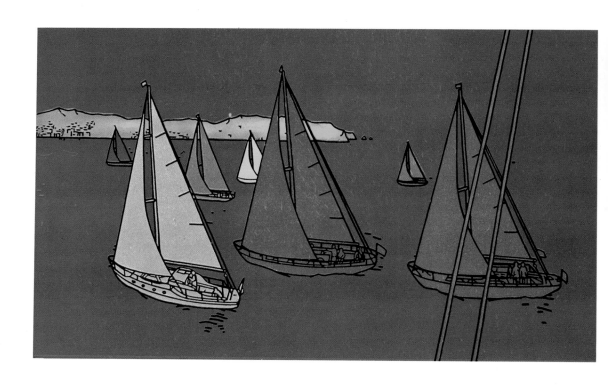

25. *Boat Race,* 1967

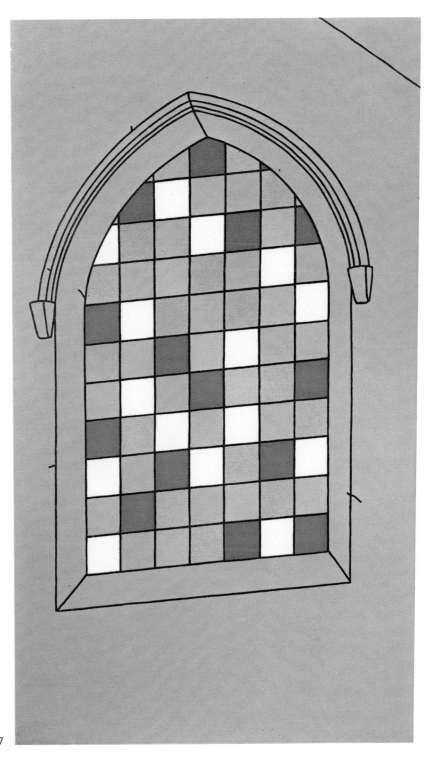

26. *Stained Glass Window,* 1967

there is a distinct difference of intention to be found in the work of the two painters — whatever superficial similarities may be observed.

Caulfield's outlines are used mainly to define areas of color (or, sometimes, to separate areas of the same color). Isolated lines become color marks — compositional devices — in their own right. They are not used to indicate motion or to evoke emotion. There is an element of

and keyed to the basic color scheme of the composition. Again, however, these generally serve to remind us of the essential flatness of the painting since they do not relate to (they may, in fact, directly contradict) any three-dimensional reading of the image in figurative terms.

In essence Caulfield seems to be expressing the same basic plastic statement over and over again. This statement has to do with what he believes to be the true nature of

27. *Parish Church,* 1967

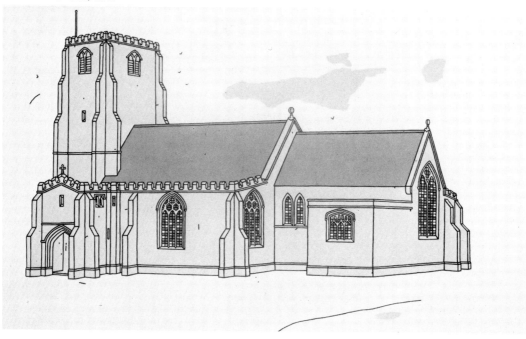

'teasing' in Caulfield's linear work since it serves to reinforce color areas which are markers of figurative imagery. They thus tempt us to read the composition three-dimensionally whereas the uniform tension of the paint surface — uncomplicated by shadow devices or tonal gradations — tells us that we are looking at a two-dimensional plane. It is true that in some compositions small areas of color seem to jump forward or recede sharply but, where this is the case, this seems to exist as a deliberate device. These areas of color puncture the picture plane so obviously that they can only remind us of its essential flatness. They amplify the irony which is implicit in Caulfield's use of the formal black outlines.

Occasionally — as in *Bend in the Road* [30] — there appear to be two distinct planes working, one in front of the other

painting (and the ironic games he plays with figurative imagery on a flat picture plane are an integral part of this). The variety involved belongs to his skill in manipulating imagery to express this basic statement. Certainly the imagery itself is of considerable interest since it sets a distinctive tone and provides the threshold of communication which we must cross in order to become engaged with the essence of his work.

The majority of Caulfield's paintings to date have been painted on board rather than on canvas. This is an integral aspect of his work. Stretched canvas has a springy quality which invites the artist to practise his dexterity with the brush — the 'give' of the surface demands a different kind of control and tempts the artist, however subtly, to indulge in calligraphy. This may be ideal for many artists but not

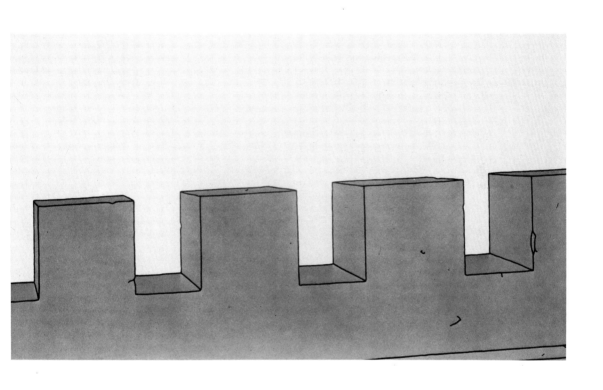

28. *Battlements,* 1967

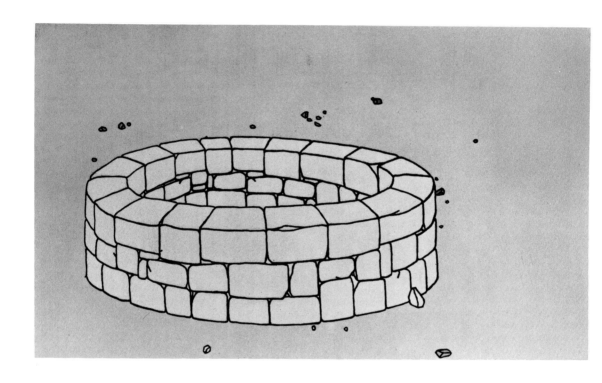

29. *The Well,* 1967

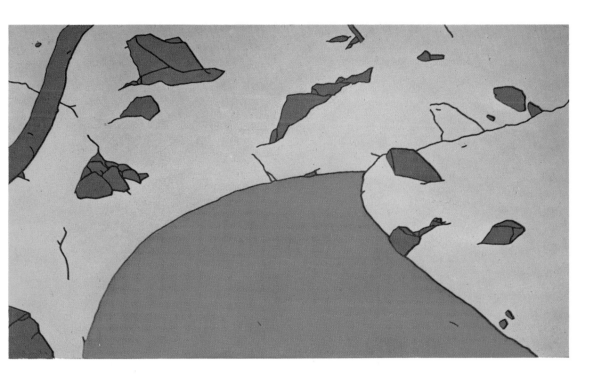

30. *Bend in the Road,* 1967

so, I think, for Caulfield's particular intents. His reason for painting on board may have been originally one of economy, but he seems to have had good reason to continue painting on board long after this factor had become irrelevant. Likewise his use of commercial gloss paints may have originally been prompted by financial considerations but, again, they proved to be very well suited to his purposes. The gloss surface which we find in much of his earlier work made a considerable contribution to his ability to achieve an overall surface tension.

Finally we might note the degree to which this overall surface tension tends to neutralize the role of composition in his work. As we have seen, Caulfield uses compositional devices with great skill but again, it seems to me, these devices belong to the threshold of communication rather than to the central concern of his work. Placed on canvas as simple graphic statements, many of Caulfield's compositions would be very animated in much the same way as are Lichtenstein's. His use of color as surface tension — always reminding us of the flatness of the picture plane — tends to hold this animation in check. Organization of imagery and surface stress tend to cancel one another out thus giving his paintings their static quality. The finished painting appears to be almost as neutral as the empty picture surface on which it was painted — only now there is something there.

The surface romanticism and the subtle irony of Caulfield's work is secondary — in the context of today's art world — to his concern for renewing painting as a viable art form. This may not be a programmatic concern on his part — certainly he is not the kind of artist from whom we might expect manifestos — but it is very real none the less. I discussed earlier the emphasis placed upon the specific object and pragmatic values in recent American art — a tendency which has drawn much attention and talent away from painting (some of its extreme proponents have gone so far as to suggest that painting is no longer a valid activity). Amongst New York artists, even those working in two dimensions have often tended to move away from painting as such. Major figures — Warhol is perhaps the most distinguished example — have substituted the mechanically-made image for the hand-painted image (and have done so with great success). The color painters — artists such as Kelly, Noland and Olitski — have continued to pursue their painterly interests, but they have often seemed more a continuation of a fifties tradition than part of a sixties mainstream. Frank Stella has tended to emphasize the object qualities of his paintings rather than the painterly qualities (though he is on record as denying that he is an 'object painter'). Jasper

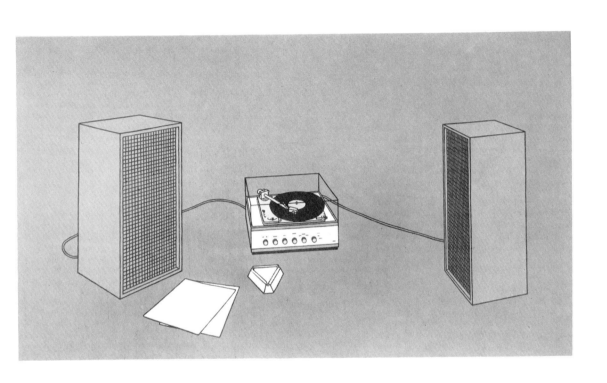

31. *Stereo Set,* 1968

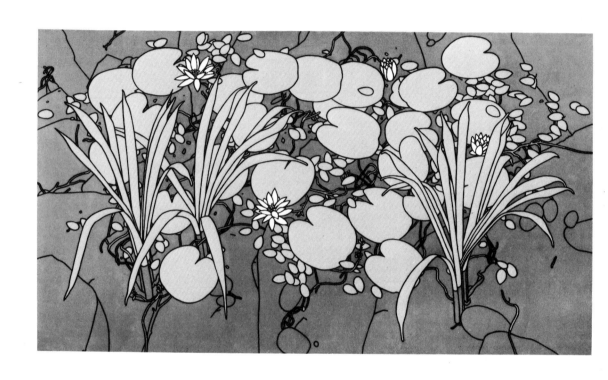

32. *Water Lilies,* 1968

Johns has continued to produce major paintings through this period; but often, when discussing his work, critics have tended to lay their emphasis on the object/painting ambiguities in his early flags and targets (Robert Morris has suggested that with those canvases Johns took painting to its limits and that, beyond that point, the specific object must, of necessity, take over). These ambiguities do undoubtedly exist in Johns' work but, in my opinion, he has continued to demonstrate, with incomparable skill, that painting is still a viable activity. Caulfield too — within the very different cultural context provided by London — has, despite the barrage of uncertainties that have unsettled many other artists, continued to paint and with results that have justified his confidence. His figurative compositions, with their many references to the past, are essentially of the present.

However close the specific objects of Morris and Judd come to ordinary artifacts, they are still art objects and function as such. In this context, painting still has validity as an art activity. Art does appear to remain separate from life — to be as much concerned with ideas as with common-sense reality — and, if this is indeed the case, then there seems to be little reason to abandon the artifice of painting which may still be a potent skill comparable with, let us say, the written word.

In this situation, Caulfield becomes an important example. He is one of the few demonstrably successful and — for want of a better word — 'modern' European artists who has managed to adhere to certain basic standards of painting. This has been no mean achievement and it has been supplemented by his use of an old-world iconography which may be incidental to his central concerns but which is none the less remarkable at the level of communication.

Artists who admire Caulfield's work sometimes express surprise at the fact that his paintings have won such a general acceptance from the art public. They seem to feel that these are essentially painters' paintings and, to an extent, it is not difficult to understand why. At a formal level, most of Caulfield's compositions are rather stark — they are of the kind that may be greatly admired in 'informed' circles but which tend to be dismissed, by the larger public, as 'arid'. With the exception of a few paintings the color does little to alleviate this problem: in common-sense terms it is too 'simplistic' to generate much 'warmth'. It would seem then — again in common-sense terms — that the paintings should appear 'cold'. This is certainly not the case and the reason for that is, I believe, to be found in Caulfield's choice of imagery. His use of the familiar may be reassuring to laymen (whereas only his skill in presenting this imagery makes it acceptable to the informed). The important point is that this familiarity is the product of a very specific cultural context — the European visual environment.

From the point of view of the European artist, just as much as that of the general public, this use of familiar imagery should prove reassuring. It makes it look possible to present old themes in new and viable ways. I am not suggesting that European artists should turn to the imagery of their predecessors and collage it into modern looking compositions. The work of the best British artists demonstrates continuity with their own cultural past without abandoning the advances of the past three decades or becoming academic; Caulfield has discovered one of the ways of doing this.

This is not the place to make any sweeping pronouncements about the future of European art and about Caulfield's position in this complex situation. It seems to me possible, however, that the future of European art may lie in a kind of informed conservatism. An important element of informed conservatism already exists within the mainstream of modern art. The classic example, for me, would be Bonnard. It seems a little strange to think of Bonnard as a contemporary of Mondrian. Yet for all the apparent conservatism of his idiom, Bonnard is clearly one of the great painters of the period. His conservatism is not the uninformed conservatism of the reactionary; it is a conservatism chosen with a full knowledge of the alternatives. Bonnard's choice must have been based on the knowledge of his own abilities rather than upon fear of change or ignorance. His originality consisted in being quite capable of adopting visual innovations although working within a basically traditional idiom. A comparable figure in the world of music would be Ravel, when one is reminded that *Le Tombeau de Couperin* was written at a time when, elsewhere in Europe, experiments with tone rows were forging a whole new idiom.

Caulfield is a painter who, in my opinion, fits very well the description of an informed conservative. He is not concerned with pushing to new frontiers, but with manipulating existing material, modifying it within the context of the art of the sixties.

It is impossible to speculate as to how Caulfield's art might develop; there is no reason to suppose that he will stray far from the idiom that he has already formulated. The character of the imagery will no doubt evolve but in what direction it would be difficult to say. However, his achievement to date is impressive. If he maintains his progress, he may become one of the most important painters of his generation.

Since this text was completed, Patrick Caulfield held an exhibition at the Waddington Gallery, London, in October 1969. The editors felt that, although impossible to incorporate a critical analysis of Caulfield's new work in the main text, it was important to reproduce a selection of those paintings and prints, accompanied by the following comments from the artist himself.

'Inside a Swiss Chalet [35] resembles a large drawing: black lines on a single color green ground. The largeness of its scale, so that it cannot easily be seen as a whole but forces the eye to travel over its surface, and the way the ground is broken up in a complicated way by black lines, can give the impression of a color change over the surface where none actually exists. At the same time, the overall green represents the light in which the interior is seen, suggesting an enveloping atmosphere.

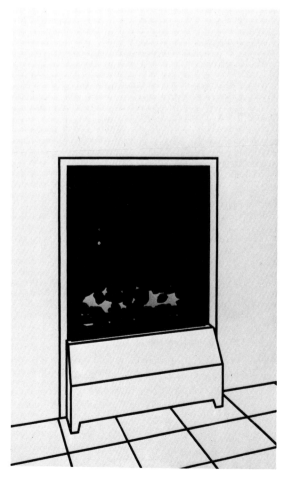

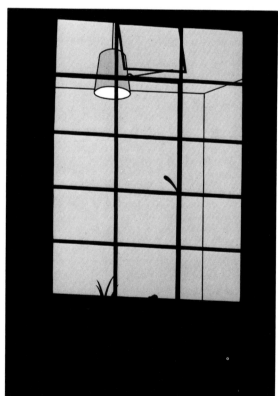

33 (left). *Smokeless Coal Fire*, 1969

34 (above). *Window at Night*, 1969

35. *Inside a Swiss Chalet,* 1969

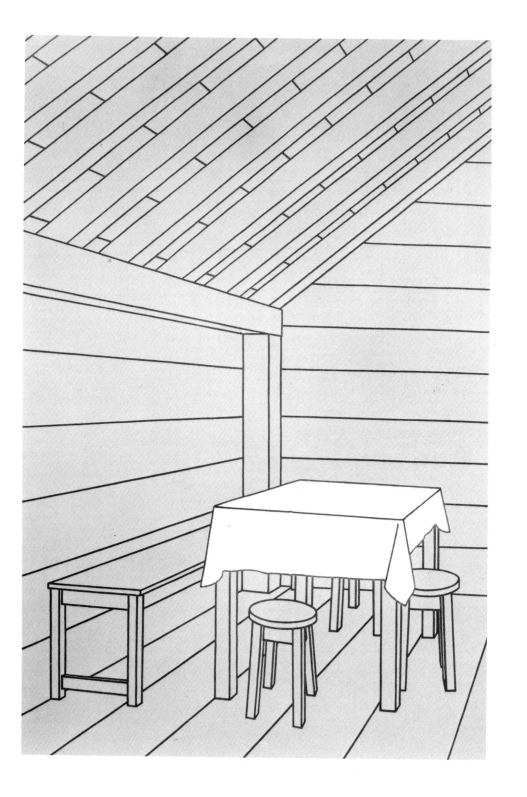

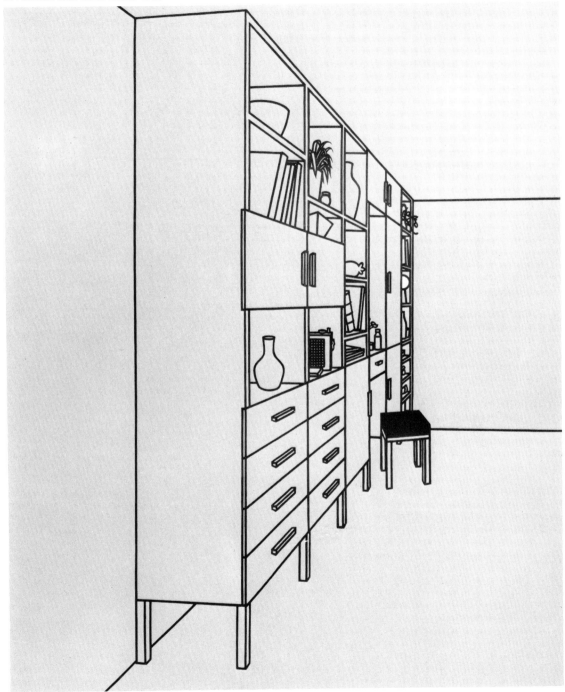

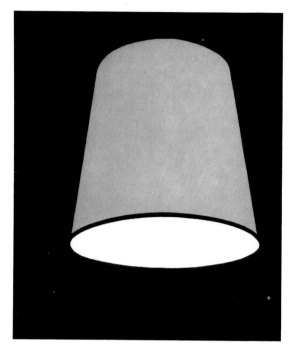

38. *Lampshade,* 1969

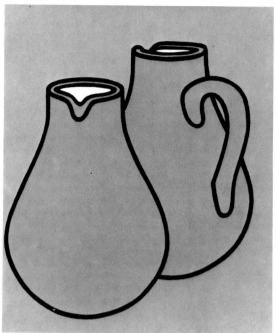

39. *Two Jugs,* 1969

40. *Wine Glasses,* 1969

41. *Coal Fire,* 1969

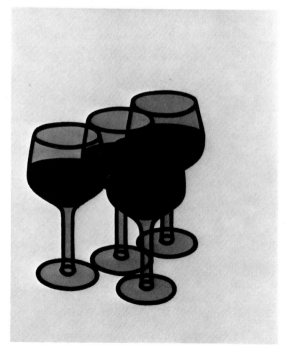

'The same overall atmosphere is intended in *Inside a Weekend Cabin* [36]. The added complication is the white tablecloth. This is the object introduced into the interior for the "weekend". It is emphasized in the painting. Its reflected light is real rather than being an area painted to represent the effect of light.

'Again, in *Interior with Shelf Units* [37], there is an overall colour — red. The brightness of this colour and the acute perspective are meant to give an unlikely drama to a mundane image. The electric light could be seen romantically as a half moon.

'In these paintings the use of perspective, giving an illusion of depth, works against the flat overall coloured ground. The frozen quality of the fixed viewpoint is emphasized: the limitations of a two-dimensional image. The subjects are imaginary, so that they are particular yet stereotyped images.

'*Found Objects* [42] is a print in which an attempt has been made to make something out of rubbish and natural objects in a way other than by an artistic metamorphosis, simply by presenting them in a formal and luxurious manner.'

42. *Found Objects,* 1969

43. *Bathroom Mirror,* 1969

44. *Loudspeaker,* 1969

45. *Crucifix,* 1969

42

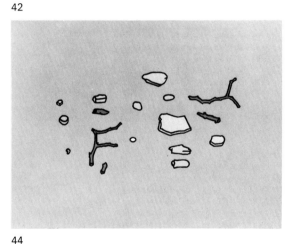

43

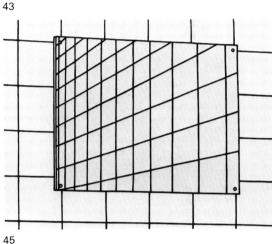

44

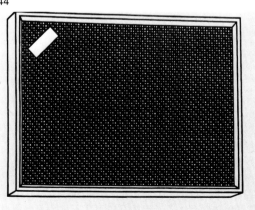

45

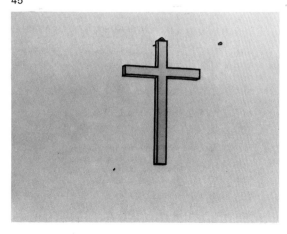

1 'The only simple explanation I can think of for these grid patterns is that they were a device to counteract the reading of the figurative elements of the painting in terms of atmospheric space; something unyielding in patterns, and static.' – *Patrick Caulfield in a letter to Christopher Finch, June 1969.*

2 'I think that a good example of this (painting *about* cubism) is the painting called *Still Life with Dagger.* This contains a device which Juan Gris used of having an area which bent around the top left of the right hand corner of the picture representing the sky or the outside of the window areas of the composition. Also it contains an Islamic dagger in jade colour, a jug, a necklace, and an abstracted palm shape. In fact it seems to contain a lot of elements I have used in my painting.' – ibid.

3 'The reasons I painted the picture in bright blue and yellow are that I see them as positive and optimistic colours which in some way reflect what I felt about Gris despite his own generally subdued palette, and that I enjoyed using such bright colours in contrast to his name "gris".' – ibid.

4 '*Greece Expiring* . . . was painted as a transcription – part of my Royal College course. My idea was to do a transcription which was very close to the original only emphasizing the "propaganda poster" quality of it. Partly hoping to achieve this by substituting for the dark, amorphous background a flat backgloss colour. This method of transcription was opposite (or different) from the usual method which was to pick out the geometrical patterns and rhythms (real or imagined) that seemed to make up the structure of the painting so that the end result was an "abstracted" version of the original – a version which diluted the essential content and over-emphasized what was a subsidiary element of the work.' – ibid.

5 '*View of the Ruins* and *Still Life with Candle* both represent a sort of "frozen decay" – that is they show the circumstantial marks and shapes caused by a process of time but represented in a static way. The subject of the latter painting is based on a classical still-life theme of the "Vanitas", minus what is perhaps its essential component, a skull. This theme represents the vanity of man by juxtaposing a skull against things of life such as fruit, musical instruments, etc., illustrating the transient nature of man's time in the world. My reason for leaving out the skull was because I thought it would be over-dramatic for the painting I wanted to do. The mouse and the overturned glass seemed enough to link it to the subject.' – ibid.

6 'The image is invented. It derives from executing the detail of battlements in the church painting of the Stuyvesant collection. I suddenly thought it was a good idea to paint just battlements as I decided to paint just one stained glass

60 window; for a variety of reasons. One only, because it was an unusual subject for a contemporary painting. The convenient way I could simplify (and yet describe) both these subjects does suggest an awareness of simple form in art today, and that obviously exists with me, as well as being a personal preference. But specific references to Judd or Morris are not made.' — *Patrick Caulfield in a letter to the Tate Gallery* (28 April 1968), *published in the Gallery's Report for 1967–8* (p. 56).

Selected bibliography

The New Generation, Whitechapel Gallery, London, 1964. Texts by David Thompson and Bryan Robertson.

Mario Amaya, *Pop as Art,* Studio Vista, 1965.

Christopher Finch, 'The Paintings of Patrick Caulfield', *Art International,* January 1966.

Christopher Finch, 'From Illusion to Allusion', *Art & Artists,* April 1966.

Robert Fraser Gallery at Studio Marconi, Studio Marconi, Milan, 1966. Text by Christopher Finch.

Mark Glazebrook, 'Print Questionnaire', *Studio International,* January 1967.

Christopher Finch, 'Spotlight on Patrick Caulfield', *Vogue* (London), May 1967.

Drawing Towards Painting 2, Arts Council of Great Britain, London, April–May, 1967. Text by Anne Seymour.

IX Bienal de São Paulo, 1967. Catalogue of British Section. Text by Alan Bowness.

Paintings by Patrick Caulfield, Robert Fraser Gallery, London, 1967.

Robert Melville, 'New Paintings at Robert Fraser Gallery', *Architectural Review,* April 1968.

Alan Bowness, *Recent British Painting,* New York, 1968, Lund Humphries, 1968.

Bruce Glaser, 'Questions to Stella and Judd', *Art News,* September 1966 (reprinted in Gregory Battcock, ed., *Minimal Art, a Critical Anthology,* New York, 1968, Studio Vista, 1969).

R. C. Kenedy, 'London Letter', *Art International,* March 1969.

Marks on a Canvas, Museum am Ostwall, Dortmund, May–July, 1969. Text by Anne Seymour.

Christopher Finch, *Image as Language,* Penguin Books, 1969.

22 *Turquoise in Matrix,* 1966. Oil on board, 22 x 36 ins. Collection: Mrs G. Boston (photo: Photo Studios).

23 *Sweet Bowl,* 1966. Screenprint, 22 x 36 ins. (photo: Photo Studios).

24 *Boats at Brindisi,* 1965. Oil on hardboard, 48 x 84 ins. Collection: Mr Harry N. Abrams (photo: Eric Pollitzer).

25 *Boat Race,* 1967. Oil on hardboard, 48 x 84 ins. Collection: Mr and Mrs Robert Mayer.

26 *Stained Glass Window,* 1967. Oil on board, 84 x 48 ins. Collection: Mr Mark Glazebrook (photo: Photo Studios).

27 *Parish Church,* 1967. Oil on board, 60 x 108 ins. Collection: The Peter Stuyvesant Foundation, London (photo: John Webb).

28 *Battlements,* 1967. Oil on board, 60 x 108 ins. Collection: The Tate Gallery (photo: John Webb).

29 *The Well,* 1967. Oil on board, 48 x 84 ins. Private collection. (photo: John Webb).

30 *Bend in the Road,* 1967. Oil on canvas, 48 x 84 ins. Collection: Mr Alan Power (photo: Photo Studios).

31 *Stereo Set,* 1968. Oil and acrylic on canvas, 60 x 108 ins. Collection: Robert Elkon Gallery (photo: O. E. Nelson).

32 *Water Lilies,* 1968. Oil and acrylic on canvas, 60 x 108 ins. Private collection, Brussels (photo: Roger Versteegen).

33 *Smokeless Coal Fire,* 1969. Oil on canvas. 60 x 36 ins. Collection: The Whitworth Art Gallery.

34 *Window at Night,* 1969. Oil on canvas. 84 x 60 ins. Collection: Mr Frank Porter.

35 *Inside a Swiss Chalet,* 1969. Oil on canvas. 108 x 72 ins. Collection: Waddington Galleries.

36 *Inside a Weekend Cabin,* 1969. Oil and acrylic on canvas. 108 x 72 ins. Collection: Waddington Galleries.

37 *Interior with Shelf Units,* 1969. Oil on canvas. 84 x 72 ins. Collection: Waddington Galleries.

38 *Lampshade,* 1969. Screenprint. $14\frac{1}{8}$ x $12\frac{1}{8}$ ins.

39 *Two Jugs,* 1969. Screenprint. $14\frac{1}{8}$ x $12\frac{1}{8}$ ins.

40 *Wine Glasses,* 1969. Screenprint. $14\frac{1}{8}$ x $12\frac{1}{8}$ ins.

41 *Coal Fire,* 1969. Screenprint. $14\frac{1}{8}$ x $12\frac{1}{8}$ ins.

42 *Found Objects,* 1969. Screenprint. $27\frac{5}{8}$ x $36\frac{1}{2}$ ins.

43 *Bathroom Mirror,* 1969. Screenprint. $27\frac{5}{8}$ x $36\frac{1}{2}$ ins.

44 *Loudspeaker,* 1969. Screenprint. $27\frac{3}{4}$ x $36\frac{1}{2}$ ins.

45 *Crucifix,* 1969. Screenprint. $27\frac{3}{4}$ x $36\frac{3}{4}$ ins.

Date Due